BRITAIN'S HERITAGE

Abandoned Villages

Stephen Fisk

AMBERLEY

Front cover image courtesy of Dawn Menzies/The Northern Light Cruising Company.

First published 2018

Amberley Publishing
The Hill, Stroud
Gloucestershire, GL5 4EP

www.amberley-books.com

Copyright © Stephen Fisk, 2018

The right of Stephen Fisk to be identified as
the Author of this work has been asserted in
accordance with the Copyrights, Designs and
Patents Act 1988.

ISBN 978 1 4456 7917 4 (paperback)
ISBN 978 1 4456 7918 1 (ebook)

Contents

1
Introduction

Most villages in Britain have grown and thrived, but some have disappeared. Sometimes villages have declined over a long period and then been abandoned. Other villages have been deserted at a single point in time.

Where the process was gradual there may have been a dominant cause. Perhaps the conditions for farming deteriorated, or people living close to the sea may have suffered sand being blown on to their fields and then entering their homes. After the closure of a local mine some people may have moved away to seek employment elsewhere, whereas others may have stayed longer and eventually departed only when their prospects became hopeless.

In cases where everyone leaves a village at the same time, it has usually happened as a result of an external decision. A powerful landowner may have decided to redesign his estate with plans that required the removal of the village, or perhaps during wartime the village was closed so that the area around it could be used for military training.

Occasionally we may get the impression that people have moved away in a voluntary fashion. The most famous example is the community on St Kilda, a group of small islands about a hundred miles west of the mainland of Scotland. In 1930 the people living on St Kilda agreed that they should leave together and go to live on the mainland. However, although the move was initiated by the people of St Kilda, it followed a long period when their living conditions had gradually deteriorated. They found the move away and the process of resettlement just as difficult and traumatic as if they had been compelled to depart.

Did you know?

The Inland Revenue never attempted to impose taxation on the people of St Kilda, and they were never invited to register on an electoral roll. No crime was ever officially recorded. No one from St Kilda was called up into the armed forces.

One major event that may have resulted in the loss of many villages was the Black Death, the episode of disease that caused the death of perhaps a third of the population of Britain between 1348 and 1350. Only a few villages are in fact known to have been destroyed at that time. Contemporary documentary evidence has revealed that Tilgarsley and Tusmore, for example, both in Oxfordshire, were depopulated directly as a result of the Black Death. Elsewhere, however, the Black Death did not lead to immediate village abandonment, but it caused enormous social upheaval, including a greater readiness to move home. In this way we can assume it made a contribution to many later abandonments.

The earliest abandonments mentioned in this book took place in the fourteenth century, and the most recent in the second half of the twentieth century. We can be sure that villages will continue to be deserted in future. It is of course not possible to predict when and where

it will happen, but two likely causes will be coastal erosion and the demands of transport. Plans for a third runway at Heathrow airport will probably require the removal of the village of Sipson, and several villages close to the coast are at risk of damage by the sea, especially if sea levels rise as a result of global warming.

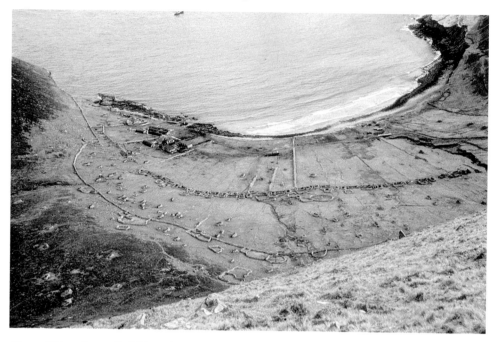

Above: Village Bay on St Kilda, with the village street strung out around the bay. The weather is often a lot rougher. The buildings close to the shore were erected in 1957 as a missile tracking station. (Ken Copeland)

Below: The former A23 at Lowfield Heath, with the perimeter fence of Gatwick airport. The road had to be diverted when Gatwick airport opened. The village of Lowfield Heath suffered a gradual decline until the last people moved out in 1974.

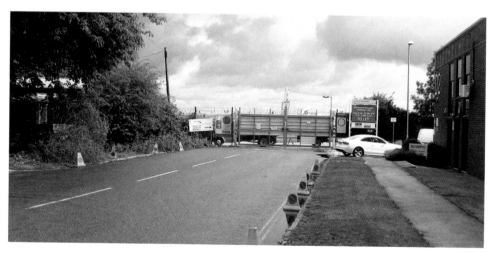

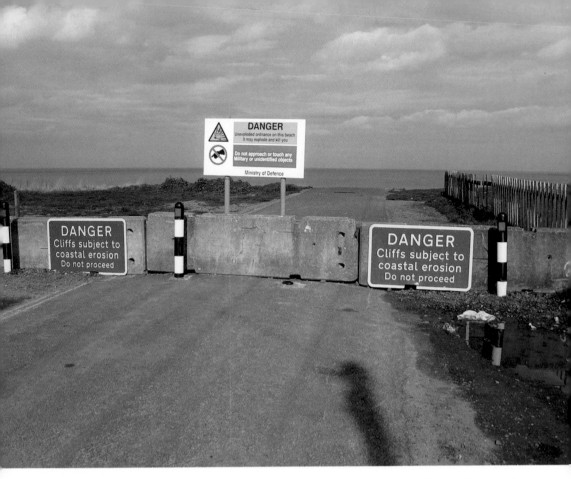

The coast of Holderness in East Yorkshire. From time to time the warning signs have to be moved further inland.

2
The Sea

The coast of Britain is continually changing. Beaches and cliffs may be eroded. High winds may cause huge movements of sand. In this chapter we will look first at the history of settlements that have been overwhelmed by sand and later I will describe the fate of places close to the sea that were destroyed by coastal erosion.

There are spectacular sand dunes on the coast of South Wales either side of Porthcawl. On the western side of Porthcawl at Kenfig, the Normans built a castle and created a small town as part of their attempt to subdue the people of Wales. The castle and town were located almost a mile from the sea. The community was probably established by Robert, Earl of Gloucester, an illegitimate son of Henry I, around 1140. The town began as a small settlement within the outer defences of the castle, but soon developed outside the castle towards the south-west – the direction of the sea. The town was given the status of a borough, and approved residents, known as burgesses, were granted individual plots of land. In 1349 there were 144 burgesses, suggesting a total population of about 1,000.

Evidence about the way of life at Kenfig comes from surviving charters and sets of ordinances. Rights conferred by the charter of 1397 included the right to elect three bailiffs every year; the right to appoint two ale tasters, men who had various food control responsibilities in addition to the task of checking the quality of ale; the right to hold two fairs each year; and rights to common pasture in defined areas outside the town, together with a small piece of arable land.

Kenfig Castle, the only part visible above the sand dunes. In 1539 John Leland recorded that the town and castle were 'almost choked and devoured with the sands that the Severn Sea casteth up'. (Barrie Griffiths)

In both the charter and the ordinances there are indications that by the fourteenth century the local people were aware of the threat from sand. The charter, for example, refers to a stream known as the Blaklaak, which 'used to run' from the southern to the northern water of Kenfig. It is likely that this stream had been covered by sand, and had either been diverted or ran underground. Among the Ordinances of 1330, the rules governing the conduct of residents, Ordinance 51 ordains that no burgess nor burgess's stranger nor inhabitant shall reap or pluck any sedges nor any other roots upon the borough without the authority of the portreeve and council.

There is in fact clear evidence that land very close to the sea was used for pasture and that the sand dunes were used as rabbit warrens. The meat of the rabbits would have been eaten and their skins used for clothing. The combination of rabbits and livestock grazing would have destroyed the vegetation that kept the sand dunes in a stable state. Patches of bare sand would have emerged and the wind would have carried it successively further inland. The people of Kenfig would have seen the sand encroaching on their land, surrounding their dwellings and eventually making its way into their homes. They probably departed in a series of stages, but the final abandonment seems to have taken place after a major storm in 1439.

There was a church at Kenfig, dedicated to St James. It was demolished and the stone blocks were transported to the village of Pyle, about a mile to the west. They were used in the construction of the new St James's Church. Go there today and you will see that smaller stones were used at the base and larger stones at a higher level, clearly representing the order in which they would have arrived.

Moving to the north-east of Scotland, and also in the early fifteenth century, sand caused the abandonment of the village of Forvie, about 14 miles north of Aberdeen. Forvie was a few hundred yards inland from the present shoreline, close to a small stream that runs into the sea at a place now called Rockend. Archaeological investigations in the 1950s found the remains of several rectangular houses, built of roughly shaped stones and red clay. There was a church dedicated to St Adamnán, which was built in the eleventh or twelfth century. All the remains of burials were dated to no later than the early fifteenth century, and it is assumed that that was the time when Forvie was deserted.

Over the following centuries sand covered a wide area around the village of Forvie, an area now known as the Forvie Sands National Nature Reserve. Much of the sand would have been brought to the sea after the melting of the last glaciers in Scotland about 10,000 years ago.

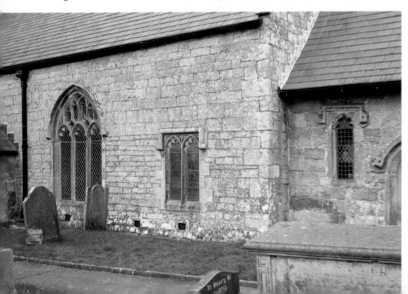

St James's Church in Pyle. As the church in Kenfig was demolished, a lot of its stone was carried to Pyle and used to build a new church.

The entrance to
St Adamnán's Church
at Forvie, looking
over the sand dunes
towards the sea.

Huge quantities of sedimentary material were transported down the River Ythan and then carried north through the process of longshore drift.

The only part of Forvie still visible today is the lower part of the church. Some impressions of life in fourteenth-century Forvie are given in a series of information points located around the site. Each information point conveys an issue, task, or a couple of facts from the perspective of a particular member of the community. A farmer's wife, for example, cares for the animals, does some work in the fields and does her best to keep sand out of the house.

Further up the coast of north-east Scotland, two other places were abandoned as a result of shifting sand around the end of the seventeenth century. The Culbin estate lay on the west bank of the River Findhorn, where it enters the Moray Firth. It contained a manor house owned by the Kinnaird family, and in 1693 there were sixteen tenant farmers. It had a reputation for the high quality of its agriculture, producing wheat, barley and oats. However, its shoreline comprised large sand dunes, and as at Kenfig the dunes were not well preserved. Heather and marram grass were collected for various purposes, and turf was cut for use in building and as fuel. In 1694 there were storms that carried enormous quantities of sand inland. The laird at the time, Alexander Kinnaird, submitted a petition to Parliament requesting a reduction in taxation in view of the damage done to the estate. In 1698 Kinnaird had to make another appeal to Parliament, this time claiming that three quarters of his estate had been covered by sand. His own house and all the farms soon became uninhabitable.

A few miles north of Peterhead the village of Rattray was abandoned as sand and shingle blocked its access to the sea. It lay at the southern end of what is now the Loch of Strathbeg. In the medieval period a spit of sand and shingle extended southwards from the northern end of a large bay, but between the spit and Rattray Head there was a channel of water wide and deep enough to allow boats to pass through. The village street ran between a castle at one end and the church at the other.

Archaeological investigations were carried out at Rattray by H. K. Murray and J. C. Murray between 1985 and 1990. They provided evidence about the construction of the houses, and also revealed that two buildings were probably used for industrial purposes – one as a pottery and the other for making a variety of metal objects. Among the excavated animal bones, some of the horse bones had signs of butchery, indicating that horse meat was eaten, at least during periods of hardship. Other finds included various objects that had been imported from elsewhere, confirming the importance of Rattray as a small port.

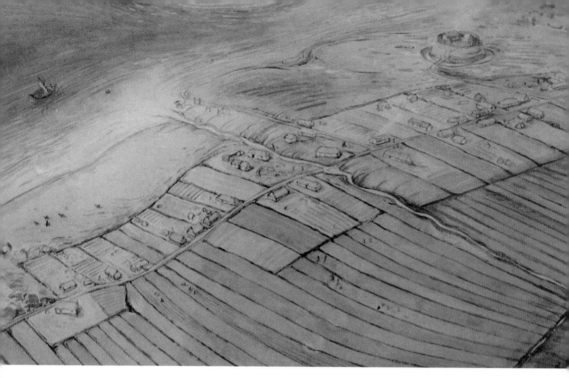

Above: An artist's impression of the village of Rattray. The channel that allowed ships to reach Rattray appears at the top. Rattray castle is shown at the north-east end of the village, and the church is at the other end.

Below: The east side of Spurn, the spit of land at the mouth of the River Humber. The location of the medieval port of Ravenser Odd is uncertain, but it may have been close to where this photograph was taken.

Early in the eighteenth century the channel at the end of the sandbar became choked with sand and shingle. Attempts could have been made to re-open it, but they failed. The population may have been declining already but it seems that the last inhabitants of Rattray left soon afterwards.

We come now to settlements that have suffered coastal erosion. Erosion of the British coastline is happening in many places, but two parts of England that are especially prone to erosion are the Holderness peninsula of East Yorkshire and much of the coastline of Norfolk and Suffolk. In the medieval period, Ravenser Odd at the southern tip of Holderness and Dunwich in Suffolk were major ports, but both succumbed to erosion and their remains now lie under the water.

The southern end of Holderness consists of a spit of sand and shingle, now known as Spurn, at the entrance to the Humber estuary. Over the centuries the position of Spurn has shifted gradually towards the west. Ravenser Odd was built at a time when the spit appeared relatively stable and it flourished for about a century from 1235. Information about the town comes from the records kept by the monks at the abbey of Meaux. The port, on the west side of Spurn, would have been well sheltered from the sea. It soon became a rival of Grimsby, attracting incoming vessels to discharge goods before they could reach Grimsby, and many merchants made a home in Ravenser Odd. As well as trade, the town benefitted from fishing. During the wars between England and Scotland the town supplied two ships and armed men in support of the king of England. In 1299 Ravenser Odd was granted a royal charter, conferring rights that included the right to build a prison and gallows.

The prosperity of Ravenser Odd was short-lived. By 1346 most of the houses and the church had been inundated by the sea. In the graveyard 'the bodies and the bones of the dead became horribly apparent'. The *Chronicle of Meaux Abbey* records the panic of the remaining inhabitants and incidents of looting.

Most of the people of Ravenser Odd found new homes in the surrounding district. It is likely that some of the merchants moved to Hull and contributed to the growing prosperity of that city.

At Dunwich the process of destruction took much longer but in the end it was equally catastrophic. At its height in the thirteenth century, Dunwich was a major centre for trade, ship

Dunwich as it may have been around 1200. The strips of yellow tape, easily removed, mark the present shoreline. (Dunwich Museum)

building and fishing. Ships from Dunwich regularly went as far as Iceland in search of the most profitable fishing grounds. The main exports were wool, cloth and grain, while imports included pottery and a lot of wine. The town had about ten churches and chapels, and two monasteries. As its fate is well known all I will do here is summarise some of the events that caused the greatest damage and then mention a couple of social factors that seem to have impaired the ability of the people of the town to cope effectively with the consequences of those events.

In 1250 the combination of strong north-easterly winds and an unusually high tide accelerated the movement of a sandbar named Kings Holme, and at its southern end it completely blocked the harbour mouth. The River Blyth, which previously had run close to Dunwich, was forced to find a new exit to the sea much further north. The prosperity of Dunwich was affected in various ways, but in particular ships from other villages to the north were now able to go to sea without having to pay tolls at Dunwich.

Then, in 1286, high tides and storms caused major erosion of the town itself. A strip of land, in places a hundred yards wide, collapsed into the sea, taking with it one or two churches and numerous homes. Disaster struck again in 1328, when several churches were lost. Houses collapsed down the cliff edge or were flattened by the wind. Some buildings, including St Martin's Church, were left hanging on the edge of the cliff.

One issue raised by the history of Dunwich is the importance of social cohesion in the aftermath of traumatic events. After the storms of 1286 we hear that twenty-one sailors and merchants were accused of flouting the authority of the mayor and bailiffs. Moreover, for the next three successive years a different group of mayor and bailiffs were elected. Such disruption of normal administration would have made it much harder for the people of the town to cope.

Another important social factor would have been the relationship with other local communities. There had always been rivalry between Dunwich and its neighbours, but the events summarised above made the relationship a lot worse. There were repeated quarrels over tolls, and a number of serious incidents of violence.

Ruins of the chapel of the hospital for people with leprosy at Dunwich, still a safe distance inland.

Did you know?

The ruins of just two buildings survive from medieval Dunwich. One is part of Greyfriars Priory, rebuilt further inland after the original priory was destroyed in the storm of 1286. The other was part of a hospital for people with leprosy, which was deliberately located some distance away from the town itself.

Two villages destroyed by erosion in the early twentieth century were Hampton-on-Sea on the north coast of Kent and Hallsands in South Devon. In both cases, however, human action played a significant part in causing the beach in front of the village to disappear.

In the early nineteenth century Hampton-on-Sea comprised a single farmhouse, a few crude dwellings and a drinking house. The income of its residents came largely from fishing and smuggling. In 1864 it became a centre for oyster fishing, and housing for staff was provided in the form of a terrace of twelve houses. Soon afterwards a pier over 300 metres long was constructed as a quay for the vessels of the oyster company. The oyster company lasted little more than a decade, going into liquidation in 1879.

The next scheme for Hampton was to develop an upmarket seaside residential estate. Ambitious plans were made and streets laid out. However, only a few more houses were built before it became clear that the beach below the houses was being steadily eroded away. There may have been occasional erosion before the construction of the pier but there is no doubt that the pier affected the flow of water in such a way that erosion was much accelerated. The last resident left Hampton-on-Sea in about 1921.

Dunwich, an etching by James Allen, dated between 1819 and 1826. In this scene All Saints' Church has been rotated so that the tower appears to be about to fall off the cliff. The church finally collapsed into the sea in 1922. (Yale Center for British Art, Paul Mellon Collection)

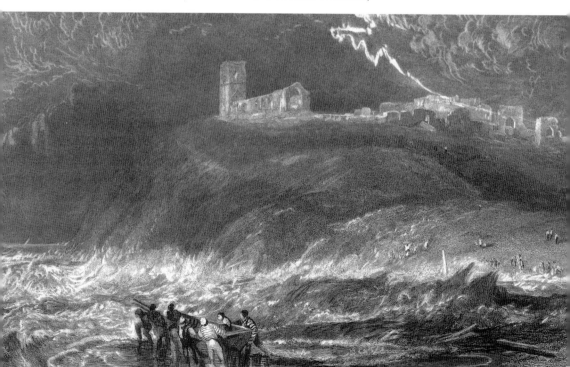

Did you know?

Edmund Reid, the police officer who led the investigation into the series of murders attributed to Jack the Ripper, lived in Hampton. After leaving the police he retired to 4 Eddington Gardens in 1903. He moved away in 1916.

The village of Hallsands in South Devon lay very close to the sea at the top of a beach of sand and shingle. In 1891, 159 people lived there, occupying thirty-seven houses. There was a small shop with a post office, the London Inn with stables and a piggery, and the Mission Room. Nearly all the men of the village made their living from fishing, and women and children too would take part in activities related to fishing.

In 1897 a major dredging operation began not far from the village. 650,000 tons of sand, shingle, and gravel were removed to be used in the extension of the naval dockyards at Devonport. Within a few years the level of the beach fell by about 12 feet as material from it moved out to sea to fill the space left by the dredging. The village was exposed to the direct impact of high tides and easterly winds. Several buildings were damaged or destroyed in storms during 1903 and 1904. Some buildings were repaired, and temporary protection was given by a new sea wall, but another major storm in January 1917 caused further devastation and nearly everyone moved away.

These events were followed closely by the local press, including the *Western Morning News*. The newspapers often commented on the reactions of the people of Hallsands and the support they received from many other quarters. They mentioned the anger, the sense of helplessness and the humour of the village people. Among those who gave support was the local Member of Parliament, Frank Mildmay, and a civil engineer, R. Hansford Worth, who in 1904 published a detailed report on the damage to the beach.

After 1917 only one person, Elizabeth Prettejohn, continued to live at Hallsands. Her house was at a higher level than the rest, and she stayed there until her death in 1964. For many years she was happy to provide guided tours of the village ruins to interested tourists.

Hampton-on-Sea, 1910, the last few houses in Hernecliffe Gardens, viewed from the west. On the left of the picture, parts of the shattered sea wall can be seen.

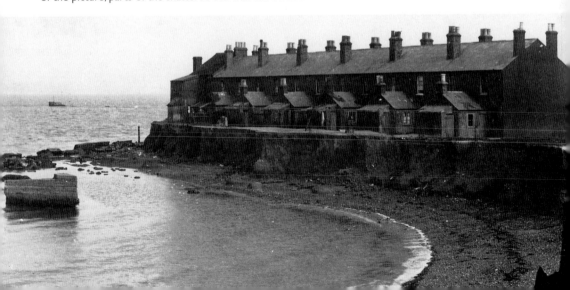

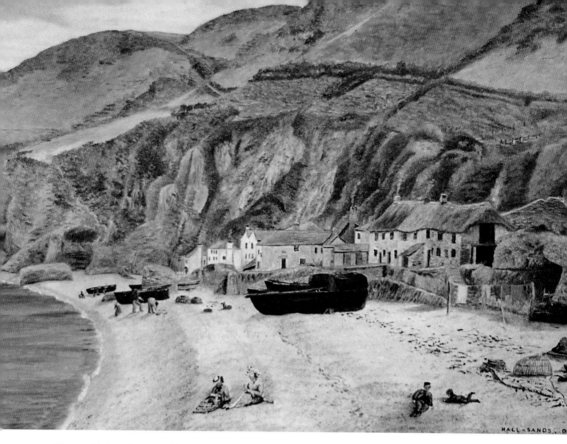

Above: *Hallsands*, painted by W. Lidstone in 1869. A calm day and the tide is out. Two fishermen are at one end of the beach, and two women are knitting at the other. The picture can be seen at the Cookworthy Museum, Kingsbridge, Devon.
Below: Hallsands after the storm of January 1917. (Cookworthy Museum)

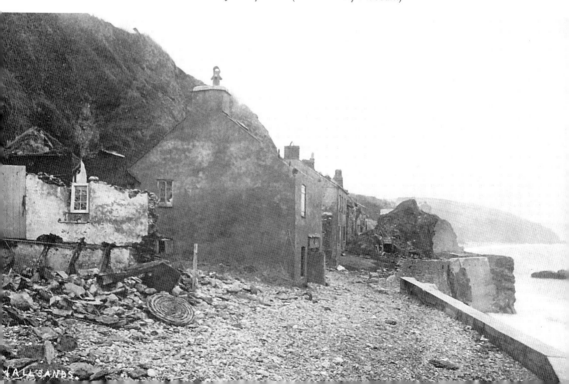

3
Farming and Land Use

In the late medieval period – the fourteenth and fifteenth centuries – very many villages were abandoned. Their legacy is often visible in the landscape today. You may see ridges that indicate the boundaries between properties or raised platforms, on which houses would have stood. Roads through and within a village appear as hollow ways, formed as a result of repeated use by people and livestock.

Nearly all medieval villages were heavily dependent on agriculture. According to the feudal system widespread at that time there was usually a single landowner, often called the lord of the manor, and each tenant would have owned a croft, where they could build a house, keep a couple of animals and grow a few crops or vegetables. Most of the farming was done in large shared fields around the village, divided into strips that were allocated to

Left: Ridge and furrow; the pattern in the field's surface was caused by the medieval method of ploughing. This field is next to the abandoned village of Littlecote in Buckinghamshire.
Below: The deserted medieval village of Gainsthorpe in Lincolnshire. Visible from the air are the vestiges of several houses, including a manor house, hollow ways, a fish pond and two dovecotes. (Historic England Archive)

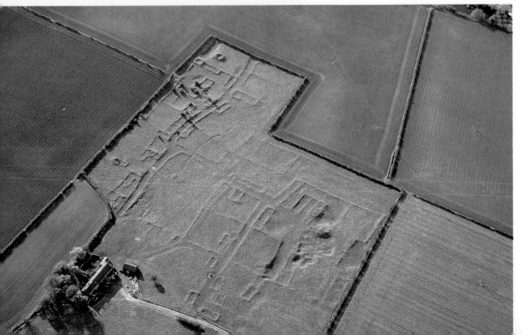

each tenant. The ridge and furrow pattern in the ground caused by the medieval method of ploughing can sometimes still be seen.

Villages were usually deserted over a considerable period of time, and various factors may have caused inhabitants to move away. The Black Death, the epidemic that swept through Britain between 1348 and 1350, caused enormous mortality. Some villages were wiped out as a direct result of it, but another outcome was that after 1350 people became more mobile. The feudal system was weakened and families would often be attracted to another village where a landowner might be offering more favourable terms.

For many deserted medieval villages farming seems to have become less productive. There is evidence that the climate became wetter after 1350. Around villages on predominantly clay soil the ground would have been much harder to work, and if crops failed for more than two or three successive seasons their residents would have felt compelled to move elsewhere. Deserted villages on clay soil include Grenstein in Norfolk, Goltho in Lincolnshire and Barton Blount in Derbyshire, all of which have been excavated by archaeologists.

At Goltho, for example, Guy Beresford found thirty-seven crofts, the site of an early manor, a chapel and a smithy. As there were few sources of stone in the area, timber was the main building material. Finds from the village site revealed that most of the crofts were deserted by about 1400, but two crofts survived for another century or so – perhaps because by then their inhabitants were relying more on livestock than arable farming.

Other villages may have been deserted because they were at a relatively high altitude. In general their fields would have been located on less fertile soil and in due course arable farming would no longer be viable. A good example is Hound Tor, which lay on Dartmoor at a height of 330 metres above sea level. Several longhouses and three barns have been discovered at Hound Tor. The barns had facilities for drying corn. In constructing their homes, the people of the village had the advantage of ample supplies of local stone. The longhouses were divided into living quarters at one end and space for farm animals at the other.

At Hound Tor grain production came to an end by 1350, but surviving fragments of pottery show that some of the houses continued to be occupied for another fifty years or so before the final abandonment took place.

At many medieval villages the end came when the landowner decided to evict the people of the village. Landowners, sometimes including the local religious authorities, realised that they could increase their income by converting the village and its fields into sheep farms – a change that would entail enclosing the fields and a sharp reduction in the number of staff required. Any remaining residents would be evicted and their homes demolished.

The best known example of a village deserted as a result of enclosure was Wharram Percy, in the Yorkshire Wolds, about 18 miles north-east of York. Over many years Wharram Percy was excavated by teams led by Maurice Beresford and John Hurst, and in addition there is considerable documentary evidence about the village.

There were about thirty-five houses in Wharram Percy, including two manor houses. The village had a church, dedicated to St Martin, and two mills, assumed to have been used to grind corn into flour. In the fourteenth century a dam was constructed, creating a pond that was probably used to keep fish.

The finds at the site included several door keys, a sign that residents were sufficiently concerned about security to have doors fitted with locks. Another find was a large stone used in playing the game Nine Men's Morris. In the churchyard, and under the floor of the church, the remains of nearly 700 human skeletons were found. Analysis of the bones has revealed

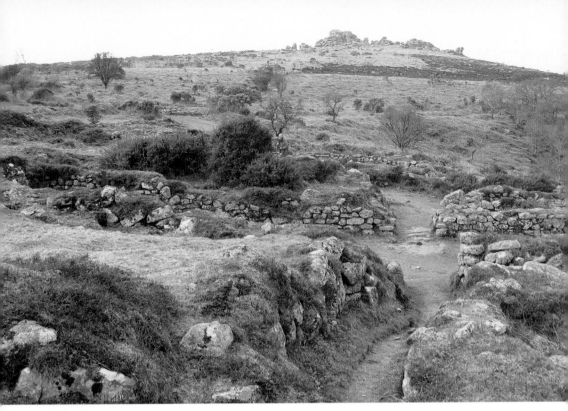

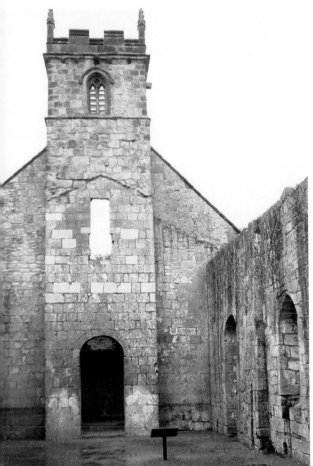

Above: Hound Tor on Dartmoor.
Left: The church of St Martin at Wharram Percy. Although Wharram Percy was deserted by 1500, the church remained in use until 1949.

The dam and fish pond at Wharram Percy. Fish were an important part of the diet of people living in Wharram Percy, as confirmed by the discovery of fish remains in the village.

much information about the physical characteristics of people living in the village, child development and growth, disease and injuries and methods of surgery. One skull contained a hole that would have been produced surgically in a technique known as trepanning. The man whose skull it was had been struck by a blunt object. The surgeon must have cut a hole in the skull and extracted the broken fragments of the man's skull. The man survived.

Some time before 1517, the residents of the last four houses at Wharram Percy were evicted by the landowner, Baron Hilton. The estate was enclosed and redeveloped for sheep.

Did you know?

The only deserted medieval village that has been reconstructed is Cosmeston, a few miles south-west of Cardiff. During the reconstruction the original building, techniques were reproduced as far as possible, and stone and other building materials were obtained from nearby sources.

Three centuries later, the most notorious series of evictions occurred during the episode known as the Highland Clearances. Again, the dominant intention of landowners was to abolish arable farming and bring in sheep. In the far north of Scotland, Strathnaver, the valley of the River Naver, was part of the huge estate of the Countess of Sutherland. In the early nineteenth century it contained about thirty clachans, small settlements with three to

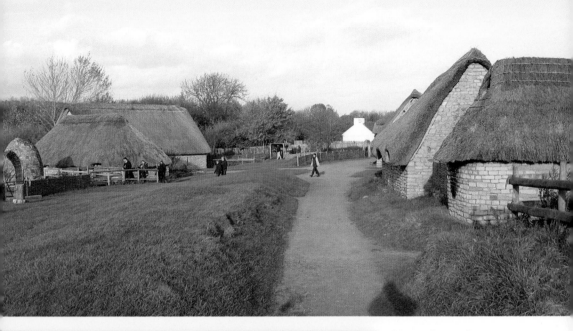

Above: Some of the farmhouses at Cosmeston. The nearest building on the right is a bakery, and on the left there is a round pigsty, which is sometimes occupied by a pig.
Left: The interior of one of the houses at Cosmeston, reproduced as the local tavern.

fifteen tenants. In addition to the tenants and their families, there were residents with no rights of tenure and itinerant people who carried out various types of seasonal work.

The people of Strathnaver spoke the Gaelic language. The rate of literacy was low, but they enjoyed coming together to play music, sing and recite poems. Their houses were constructed out of materials obtained locally, such as turf, stones, a limited amount of wood, clay and thatch. They were cramped, poorly ventilated and very dark.

The first phase of evictions in Strathnaver took place in 1814. The husband of the countess, the Marquis of Stafford, had received two enormous legacies a few years earlier and his money was used to re-develop her estate. The evictions were managed by the agents of the countess, William Young and Patrick Sellar. They offered crofts on the coast to some of the

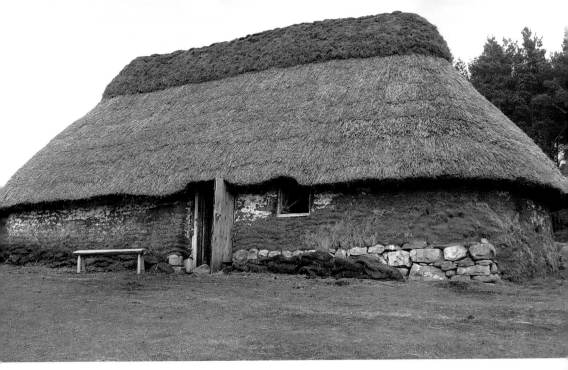

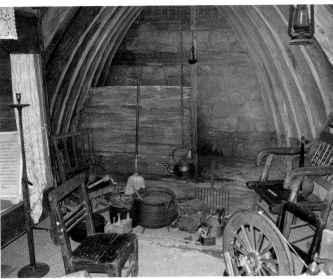

Above: A longhouse home, typical of the houses occupied by tenants in the Highlands of Scotland at the beginning of the eighteenth century, seen at the Highland Folk Museum in Newtonmore.
Right: A simulated house interior at Strathnaver Museum. It is possibly a little more cluttered than it would have been at the beginning of the nineteenth century. (Strathnaver Museum)

tenant families, but in other respects they acted with no consideration for the welfare of those who were forced to move out.

On Monday 13 June 1814, a posse of four law officers and twenty men went from one clachan to another, removing anyone still inside their home and then setting fire to each house to make it impossible for it to be re-occupied. Sick children, pregnant women and very old people were all required to leave. The elderly mother of William Chisholm had to be carried from her home as the flames spread around her. According to a local observer, the stonemason Donald MacLeod, she cried out, 'God receive my soul! What fire is this about me?' She did not speak again, and died five days later.

Above: The grassy clearing in Langdale, Strathnaver, where a large and very emotional service was held on the 'last Sabbath' in May 1819.
Below: Glencalvie in Strathcarron, the estate that was cleared in 1845.

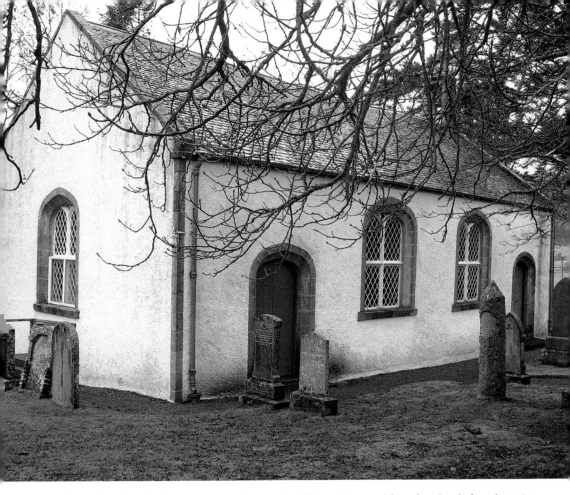

Croick church in Strathcarron, where the people of Glencalvie stayed for a few days before departing. On the left you can see the east window, where messages were scratched to record their plight.

The clearance of Strathnaver was completed in 1819. On the last Sunday before the date of evacuation, a local minister, Donald Sage, led an open air service in a grassy clearing in Langdale. In his *Memorabilia* he reported that he managed to complete his sermon but then he and the congregation broke into weeping. On the day itself the listed houses throughout Strathnaver were set on fire. The events were recorded again by Donald MacLeod, who summarised his observations by saying: 'Nothing but the sword was wanting to make the scene one of as great barbarity as the earth ever witnessed.' One man, Robert MacKay, whose whole family was sick, carried his two daughters on his back for 25 miles. He would carry one for some distance, lay her on the grass, then return to collect the other.

Some of the people evicted in 1819 resettled on the coast, facing a marginal existence based on fishing and gathering kelp. Others moved to neighbouring estates or south to the Lowlands and cities of Scotland or into England. Some joined the steady stream of people from the Highlands migrating to countries overseas.

Equally traumatic were the clearances in Strathcarron, about 40 miles south of Strathnaver, involving the estates of Glencalvie and Greenyard. Again, the landowner's intention was to convert the land into sheep runs. Glencalvie was cleared in 1845, Greenyard in 1855. On both occasions the local people provided stiff resistance and they suffered a good deal of serious

violence. Women featurèd prominently in the resistance at both estates and were strongly supported by others from neighbouring communities.

Two unsuccessful attempts were made to serve eviction notices in Glencalvie in 1842, and then in 1845 a further attempt was made. The events that followed were reported in detail by a reporter from *The Times*. On 25 May the reporter found that nearly everyone from Glencalvie, a total of eighty people, had moved into temporary shelter in the churchyard at Croick. Within a week they had all moved away. Six families had found alternative homes, but we do not know what happened to the rest. Look at the window at the east end of the church and you can see the messages scratched on the glass by the people of Glencalvie.

Greenyard is famous for the attempt made in 1854 to deliver eviction notices. On 31 March a band of officials and police constables were approaching the Greenyard estate when they were confronted by a large group of women and children, with a few men in the background. They were instructed to give way, but when they refused the senior officer ordered the constables to clear the way and knock them down. The police rushed among the women, striking them violently on the head with batons and levelling them to the ground.

Nineteen women and four men were seriously injured. One of the women, Grace Ross, was beaten on the forehead and knocked unconscious. In due course she made a good recovery, and later in life she would demonstrate her injury by placing a button in the depression on top of her head.

The eviction process in Greenyard was completed about a year later.

4
Estate Development

In the seventeenth and eighteenth centuries, a few people, usually men, were very wealthy. They owned a great deal of land and lived in very large and ostentatious houses. Small villages within their estate were often regarded as unsightly by the landowner or interfered with his plans for developing the estate. They might be allowed to decline gradually, but sometimes they were deliberately depopulated. A replacement village might be created on the edge of the estate out of sight of the main house, especially if there was a need to provide accommodation for people employed on the estate.

The Stowe estate in Buckinghamshire was exceptionally large and contained four villages. One village, Dadford, still exists, but Boycott, Lamport and Stowe itself have been abandoned. In the early part of the seventeenth century the owners of Stowe, the Temple family, converted part of the estate into a deer park.

Some insight into life on the estate during the century before the creation of the deer park can be gained from surviving documents that include taxation records, court records and wills. In 1524, during the reign of Henry VIII, the lay subsidy roll for Buckinghamshire indicates that there were thirty-two taxpayers in the village of Stowe. Fourteen people are described as servants, with estimated annual wages of £1 each. Out of the £1 they had to pay 4*d* in tax. There were two widows, one of whom, Jane Gyfford, owned land worth £30. From court records we know that a miller in Boycott was fined for allowing water from the mill

The parish church at Stowe, which is still in use. Brass memorials on the floor inside the church include one for Anne Saunders, who died on 1 September 1454.

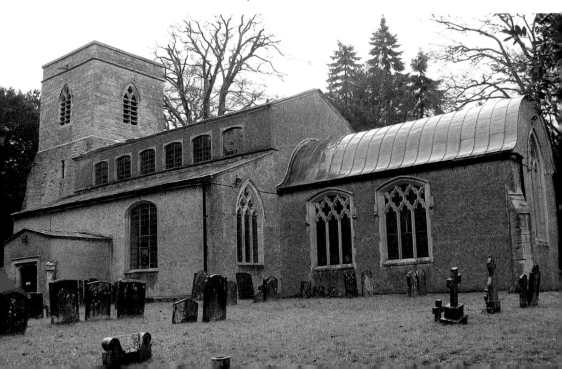

Part of the gardens at Stowe known as the Elysian Fields, where the village of Stowe itself would have been.

stream to overflow and flood a meadow. Then, in 1569, a shepherd was in trouble for letting his sheep graze in the growing grain. In 1601 Edward Seare was fined for keeping one bullock more than he was allowed, while in 1625 tenants were fined for not grinding their grain at the lord's mill and for not repairing the stocks.

The will of William Sherytt survives, bearing the date 1588. The inventory of goods attached to it includes a mare and a colt, two sheep, three hens and a pullet, three flaxen sheets, all the apparel that pertained to his body, a table, a form and a chair, a frying pan, a spit and a pair of pothooks, a feather bed and a bolster and three pounds of hemp.

In March 1633 a Mr Allen carried out a survey of the estate to be used in guiding further developments. It lists nineteen tenants in the manor of Stowe. Thomas Shurte, for example, is shown as occupying just over 23 acres, most of it in the open fields and a few acres around his house.

The exact location of Stowe village is not known but it is assumed it lay close to the church that has survived, among the area now known as the Elysian Fields. The Hey Way, a road that ran north to south on the eastern side of the church, was probably the main road through the village.

As the deer park developed it would have been enjoyed by the Temple family for hunting, the results of which could be eaten or sold. Dan Beaver has argued that another motive for developing a deer park would have been to enhance the family's social status, or 'honour'. Their actions were strongly opposed by the owners of neighbouring estates, but in particular they created major difficulties for their own tenants. Some tenants may have chosen to move away, but in addition a petition to Parliament by the neighbouring Dayrell family in 1642 asserts that Peter Temple had evicted the farmers from ten or twelve ancient farms, along with a number of poor people. The village became entirely deserted soon after that date.

The Boycott estate was acquired by the second Richard Temple, later Lord Cobham, around 1720. The houses of Boycott village were probably demolished soon afterwards. Lamport village must have survived until the second half of the nineteenth century as it appears on a tithe apportionment map produced in 1850.

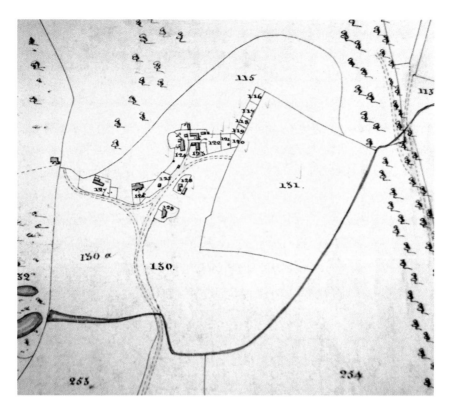

Above: The village of Lamport on the Stowe estate, shown on a tithe apportionment map of 1850. The village may have been removed soon afterwards.
Below: Part of a map of Milton produced for Joseph Damer in 1769. Properties marked as 'in hand' are those already controlled by Damer.

Left: Fishmore (or Fishway) Hill, once the road leading out of Milton to the west. (Helier Exon)

Below: Greenwalk Cottage, one of two cottages surviving from the old Milton. It is believed that the mistress of Joseph Damer lived in this house.

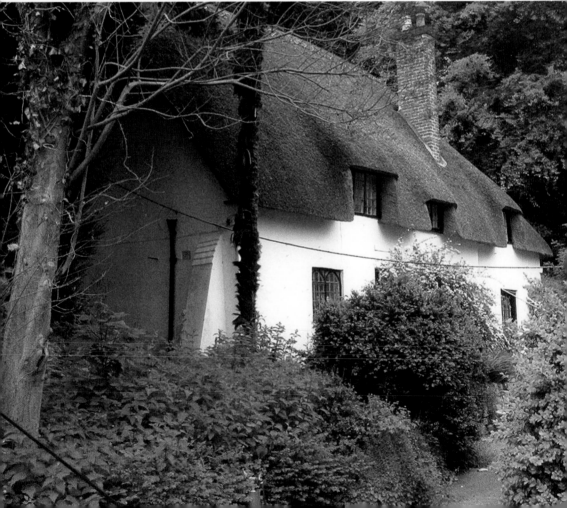

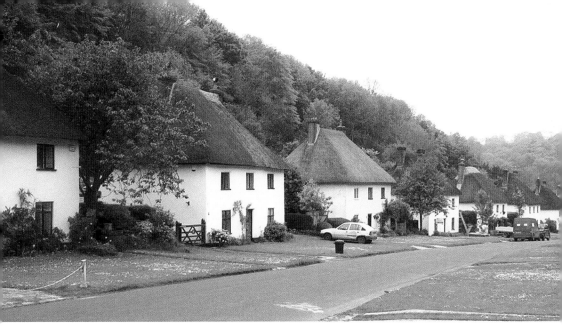

The village of Milton Abbas, built in a valley well away from the main house at Milton. Across the road from these houses there are almshouses that were rebuilt to be as they had been in the old town.

Milton, in Dorset, was a town with a history going back at least as far as the tenth century. In 1752 it had several streets with shops and houses, a grammar school, two inns, the Red Lion pub and an abbey church. The town had a weekly market and an annual fair.

In 1752 Milton was bought by Joseph Damer. Before long Damer decided to modify his estate in a scheme that included the removal of the town and the creation of a large park. A map of 1769 indicates that some residents had already been persuaded to move out. Another map from 1776 reveals that, in the intervening seven years, most of the other residents had left as well. The remaining inhabitants proved more difficult to evict. In particular William Harrison, a lawyer, had leases on four properties in various parts of the town and had no wish to surrender them. Damer showed his displeasure by opening the sluice gates of an old pond and allowing the water to flood one of Harrison's houses. Harrison took legal action and eventually won the case. The process of emparking could not be completed until William Harrison died. Damer also decided that he could not tolerate the close proximity of the grammar school, and in 1785 he obtained Parliamentary consent to have it moved to Blandford.

Only two houses were left standing in the town. One of them, now known as Greenwalk Cottage, was occupied by a woman thought to be Damer's mistress. Building materials from the demolished buildings were transported to a valley out of sight of Damer's house and used in the construction of a new village, Milton Abbas.

Did you know?

Oliver Goldsmith's splendid poem 'The Deserted Village' was inspired by the destruction of the village of Nuneham, a few miles from Oxford. Over fifty families were removed in 1760 to satisfy the requirements of the landowner, Lord Harcourt:
 'No busy steps the grass-grown foot-way tread,
 But all the bloomy flush of life is fled.'

5
Reservoirs

In the more hilly regions of Britain, many reservoirs have been created to supply water to more populated areas. Water has, of course, always been needed for domestic use, and since the nineteenth century the demand from industry has also steadily increased.

Many of our reservoirs have damaged farming communities and sometimes caused villages to be abandoned. This chapter will mention a number of reservoirs where villages were submerged by rising water after the dam was completed. In other cases land above the water has lost its agricultural value or become unattractive in other ways and people have felt obliged to move away.

Just outside Rochdale, in Greater Manchester, three valleys have suffered the loss of their communities as a result of reservoirs. In the Cowm valley the reservoir was completed in 1877. In 1851, 139 people lived in the valley, some in the hamlet of Cowclough and others in houses scattered around the valley. Some were farmers while others worked in a cotton mill and quarries at the north end of the valley. A few houses were lost under the reservoir and then the rest of the valley was gradually deserted.

The ruins of a building at Cowclough, Cowm. The space between the stone slabs would have been used to store fuel or animal food supplies, or for occupation by farm animals. Cowm Dam and Reservoir can be seen in the background.

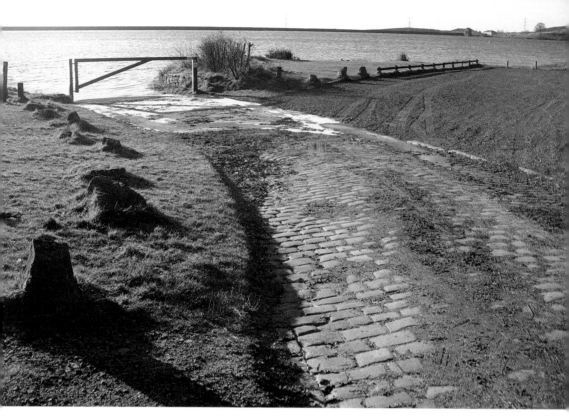

The Ramsden Road as it emerges from the Watergrove reservoir. The road surface is paved with stone setts, which were common throughout Lancashire in the nineteenth century.

One resident of Cowclough, Owd Mrs Butterfly, used to make butterflies, possibly knitted or crocheted, and take them round in a basket to sell them. Visitors to Cowclough included Donkey Bill, who would come round regularly with a jug of black peas and a basket of tripe, and Squire Clegg, who walked up from Rochdale with articles of haberdashery in a large pack on his back. Cowclough became empty in 1928 and the last inhabitants of Cowm Valley left in 1950.

Villages were submerged under both the Watergrove and the Greenbooth reservoirs. In both villages textile mills were opened in the 1840s and the villages were created to provide accommodation for the staff. In Watergrove most of the buildings were on the west side of the main road through the village, Ramsden Road. They included a farmhouse, the Orchard public house, a Methodist church and several groups of houses. There was a side road that led to a terrace of houses known as Bowers Row. The mill lay just outside the village, on the east side of Ramsden Road. Elsewhere in the valley there were several other farms and small hamlets, most of which were at a higher altitude.

The dam at Watergrove was constructed in the 1930s and the reservoir was opened on 6 April 1938. Well before that date the water board insisted that nearly everyone should move out from the valley, including people living above the water line. The last service at the Methodist church took place on Sunday 23 July 1933. The final hymn, with Mr H. Sykes on the organ, was 'God Be With You Till We Meet Again'.

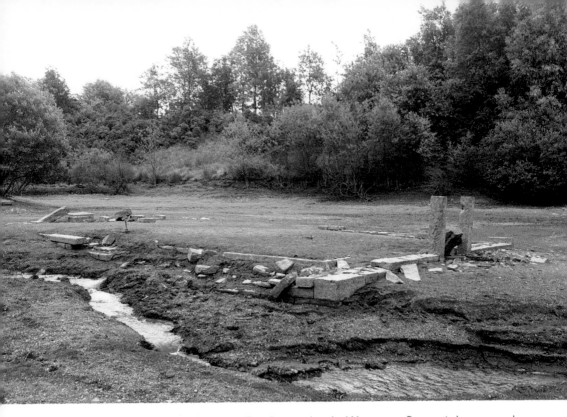

Above: The foundations of a building normally submerged under Watergrove Reservoir but exposed during dry periods and seen here in July 2013. (Helen Percy)

Below: Greenbooth Reservoir; the seagulls on the surface of the water mark the spot where the village used to be.

Greenbooth Reservoir was completed in 1963. It was named after the village that now lies beneath it. The village consisted of two rows of terraced housing and larger houses for managers. There was a shop and a school. The memories of several former residents have been recorded. They often refer to Mrs Hutchinson, the wife of the mill owner. She travelled around the village in a horse-drawn carriage, and even a dirty door step would bring a sharp reprimand from her.

The mill in Greenbooth closed in 1911. After that date the inhabitants of the village tended to move away, so that by the time the reservoir was created only about half of the forty-six houses were still occupied. Most of the people still living in Greenbooth found new homes in Norden or Rochdale.

Haslingden Grane is a valley west of the town of Haslingden in Lancashire. Around the middle of the nineteenth century it contained a thriving community. About 1,500 people lived in the valley – some 600 of them in a village close to the main road to Blackburn and the rest in several dozen farms and hamlets scattered around the valley. Apart from farming, the main occupations were quarrying and textile production. Until the 1840s weaving was done on looms installed in the home, and then local people were employed at the Calf Hey cotton factory a short distance south-east of the village. In the village there was a school, a Methodist chapel and St Stephen's Church.

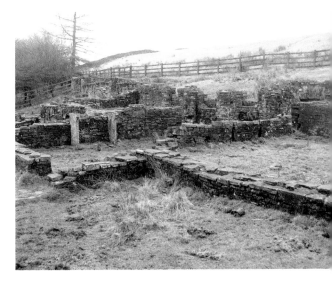

Hartley House in Haslingden Grane. If you explore the ruins you will find the loom rooms, a well and what appears to be a dairy.

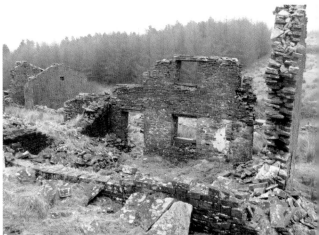

Top o' th' Knoll in Haslingden Grane. For about fifty years from the 1830s, Top o' th' Knoll was the home of Andrew Scholes, otherwise known as Owd Andrey – a man of many talents.

The ruins of several of the smaller settlements in Haslingden Grane can still be seen today. At Hartley House, for example, there were four farms and six other dwellings in 1827. Two of the farmhouses had recently added loom houses in order to expand the space for weaving. However, after 1850 the hamlet gradually declined. Only four of the dwellings were still occupied in 1881, and the last resident departed in around 1900.

Three reservoirs were constructed in the lower part of Haslingden Grane, beginning with Holden Wood in 1842. The third reservoir, the Ogden, opened in 1906. By that date the water board were concerned about pollution of the water flowing down the valley. They bought up much of the land and failed to renew leases as they expired. Life became increasingly difficult for the remaining residents, and by the early 1920s nearly everyone had moved away.

Haslingden Grane is a good example of a community to which former residents continued to feel a strong sense of attachment. For many years there was a tradition of getting together for an annual tea party. In 1933, for example, 430 people attended the tea party. The tradition was revived in 1991, when there was a large gathering of people whose ancestors had lived in Haslingden Grane.

Three large reservoir systems in Wales were created with the intention of supplying water to cities in England. In the 1880s Liverpool Corporation organised the damming of the River Vyrnwy in north Wales. The new Lake Vyrnwy submerged Llanwyddyn, a village with a church and two chapels, three pubs, at least two shops, one of which contained a post office, and about thirty-seven houses. We know about several of the people living in the village. For example, there was no doctor or nurse in Llanwddyn, but Erasmus Owen, whose main job was village blacksmith, provided an important service when people were ill or injured. He could offer treatment for accidents, burns and scalds, sprains, bleeding of arteries or veins and fractures.

The Garreg Ddu submerged dam in the lower Elan Valley. The roadway to the neighbouring valley of the River Claerwen runs along the top of the dam.

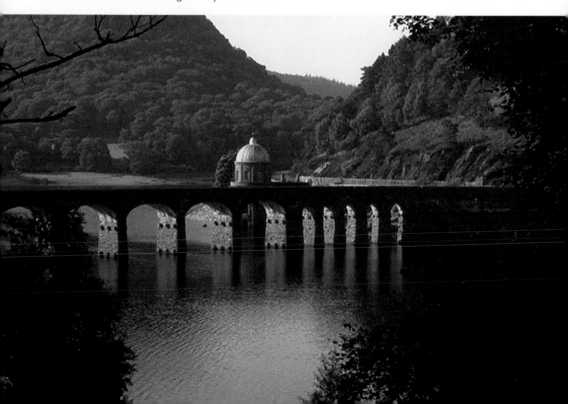

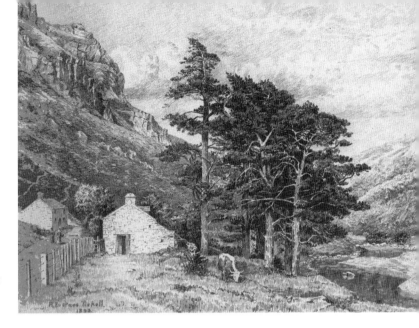

Tan-y-Foel in the Elan Valley, as seen in an etching published by R. Eustace Tickell in *The Vale of Nantgwilt: A Submerged Valley*, in 1894.

Twenty years later the spectacular Elan Valley system of reservoirs was constructed in Mid Wales, with an aqueduct to transport its water to Birmingham. On this occasion no entire villages were flooded, but two large houses, a small church, a Baptist chapel and eighteen cottages and farmhouses had to be submerged.

Did you know?

The poet Shelley had long holidays in the Elan Valley in 1811 and 1812, staying at Cwm Elan and Nant Gwyllt. In 1812 he was accompanied by his first wife, Harriet, and during that holiday he wrote a long poem, 'The Retrospect', about the scenery in the surrounding district.

In the 1950s the Liverpool Corporation was again searching for a source of additional water. They chose the Tryweryn Valley and planned a scheme that would entail flooding the village of Capel Celyn and the local farming community. On this occasion there was far more opposition. In November 1956 a march through Liverpool itself was organised. Apart from a child aged one month, everyone from Capel Celyn and the surrounding area took part in the march. Earlier that year the Tryweryn Defence Committee had been created to co-ordinate much wider opposition. The Liverpool Corporation had to apply to Parliament for permission to go ahead with their scheme. The bill was opposed by all but one of the members of Parliament representing Welsh constituencies, but they were in the minority and the bill became law on 1 August 1957. The construction of the dam on the River Treweryn and the creation of a lake, Llyn Celyn, went ahead.

In Wales the flooding of the Tryweryn Valley continued to arouse anger, coupled with demands that much more decision making should be devolved from the UK parliament to the people of Wales.

In October 2005 the Liverpool council voted to publish an apology for the way in which the Tryweryn Valley had been flooded: 'For any insensitivity by our predecessor council at that time, we apologise and hope that the historic and sound relationship between Liverpool and Wales can be completely restored.'

Above: The Shelley memorial near the Elan Valley visitor centre. Created by Christopher Kelly in 1988, it represents the poet Shelley deep in thought, surrounded by four female muses.
Left: The A4212 as it enters Llyn Celyn.

6
Mining and Industry

Mining, quarrying and manufacturing all grew rapidly during the nineteenth century. At that time most workers would have walked to their place of work. It was often necessary for companies to provide housing for them and before long a small village would be likely to develop, with shops, a pub or two and places of worship. Many such villages still exist, but here we will consider some of those which have not survived. Life in these villages became more difficult after the local company ceased to exist, especially if the responsible housing authority failed to maintain the houses in good condition or provide modern amenities such as an electricity supply, and eventually the people would move away.

Several abandoned villages in Mid Wales and across the border in Shropshire were associated with lead mining. In both areas lead was mined during the Roman occupation and then again from the seventeenth century. At Dylife, about 10 miles south-east of Machynlleth, the mines reached their highest level of productivity after 1858, when they were acquired by a company headed by two prominent politicians, Richard Cobden and John Bright. Housing was provided among the buildings and machinery used to run the mines. There were three chapels and St David's Anglican church, a school and three inns. By 1864 the population was about 1,000. However, by 1873 the lead mines were in decline and they closed in 1901. As the people moved away they would at least have had the advantage of alternative employment opportunities in the coal mines of south Wales.

In Shropshire, lead and other metals were mined in the large hill known as the Stiperstones. Several small villages provided accommodation for miners and their families, but some of them have become uninhabited. In a village happy to be called The Bog, for example, the population reached 248 in 1861. By 1851 The Bog had a school serving both the children of the village and others from the surrounding area, and there was a pub, the Miners' Arms. Apart from those working in the mines, other occupations recorded for people living in The Bog were shoemaker, carpenter, blacksmith, wheelwright, carter, tailor and police constable.

By the early twentieth century only a little lead and zinc was being produced on the Stiperstones, and the population of The Bog fell to eighty-nine in 1911. However, the school survived until 1968, also serving as a community centre. Dances were much enjoyed and the proceeds were used for charitable purposes; for example, assisting a family who had difficulty paying the rent. Seven families were still living in The Bog in 1973, but soon afterwards nearly all the houses were demolished.

Another village that lasted for several decades after the close of its industry was Tide Mills near Newhaven on the coast of East Sussex. Tide Mills gained its name from a flour mill that opened there that derived its power from tidal energy. A storm in 1876 badly damaged the mill, and it was closed in 1883. However, the village survived until 1940. From recorded reminiscences of people living at Tide Mills we know that it continued to be a small but happy community, but at the start of the Second World War the area around it was requisitioned by the military authorities for coastal defence and the houses were demolished. One resident, Stan Tubb, stayed a little longer than the rest as his combination of military experience and local knowledge was useful to the troops based at Tide Mills.

Part of the row of cottages called Rhanc-y-Mynydd at Dylife. Some of the other cottages in Rhanc-y-Mynydd have been restored and have become homes again.

The view from the churchyard of St David's Church, Dylife.

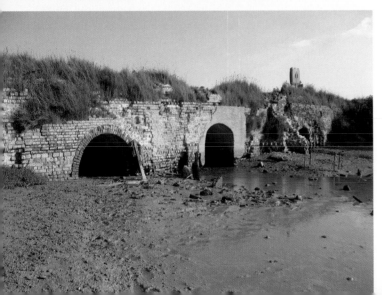

The three arches under the flour mill at Tide Mills, seen from the tidal channel on the west side. As the tide went out water would flow from the mill pond and drive undershot water wheels housed in the arches.

The ruins of the station master's house in Tide Mills. The house lay at the northern end of the village, near the railway line.

At Binnend in Fife, close to the north bank of the Firth of Forth, a huge industrial complex exploiting shale oil was established in 1878. A village was built to provide accommodation for workers and their families.

The shale oil company prospered at first but soon went into decline, subsequantly closing in 1894. The population of the village gradually fell, and then in the 1930s the owners of the village decided to withdraw maintenance of the houses. However, the last few people did not leave until the early 1950s. One factor that preserved the viability of the village until then was that it became popular as a holiday destination during the summer. It was still possible to use the old school hall as a venue for dances and concerts.

Porth y Nant was a small village in the Llŷn peninsula in Gwynedd. It was occupied by people who worked in the local granite quarry, from where granite setts and crushed granite were transported by sea to Liverpool. It is notable for its wonderfully scenic setting, and also for the use to which it was converted after its abandonment. There was a small school in Porth y Nant, but any children who wanted to stay in school after the age of fourteen had to walk up a steep and winding track known as the Screw to reach the main road and then catch a bus to Llithfaen.

The granite quarry at Porth y Nant closed early in the Second World War. A few people went on living there until the mid-1950s, but then the village was deserted and started to fall into ruin. It was bought in 1978, fully restored and opened again as the Nant Gwrtheyrn Welsh Language and Heritage Centre.

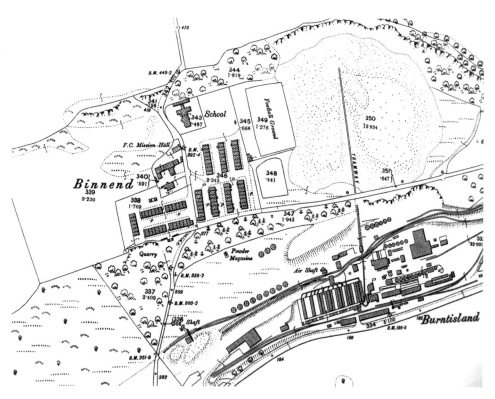

Above: Map of Binnend, showing the village and the Burntisland shale oil works. The Firth of Forth appears at the bottom of the map.
Below: Ruins of The Square, at the western end of Binnend.

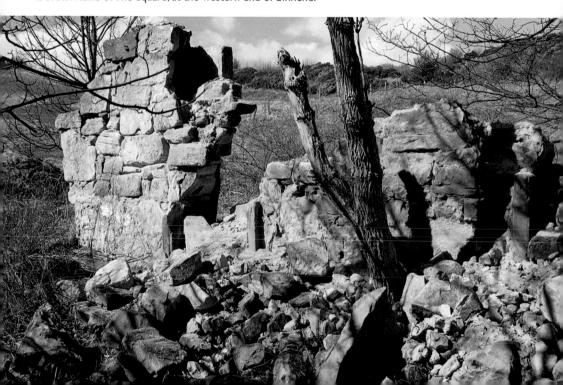

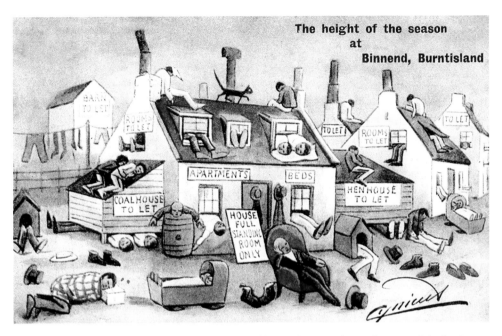

The height of the season
at
Binnend, Burntisland

Overcrowding during the holiday season in Binnend. If you take away the coalhouse and the henhouse, it is in fact a surprisingly accurate representation of the houses at Binnend.

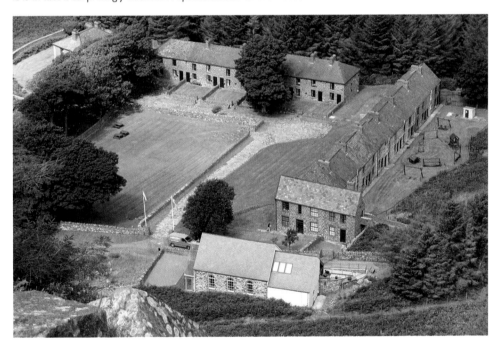

Porth y Nant from above. The terrace of houses on the right, Sea View, faces west towards the sea, while Mountain View in the distance faces the mountain. The former residence of the quarry manager, the Plas, can be seen beyond the trees at the western end of Mountain View.

Above: Scattered bits of machinery around the former quarry workings at Porth y Nant.
Below: Sea View and the former Capel Seilo at Porth y Nant. Capel Seilo now houses the visitor centre for Nant Gwrtheyrn Welsh Language and Heritage Centre.

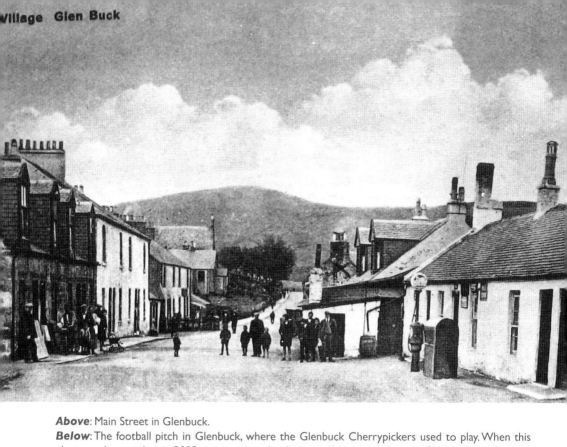

Above: Main Street in Glenbuck.
Below: The football pitch in Glenbuck, where the Glenbuck Cherrypickers used to play. When this photograph was taken in 2008, open-cast coal mining was being carried out at Glenbuck.

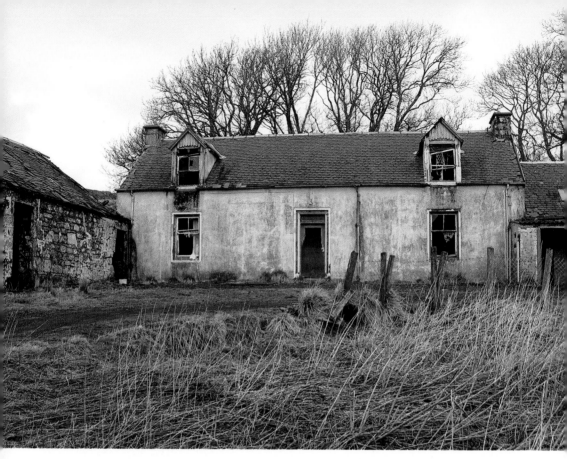

Glenbuck Farm, on the hillside above the coal mining area. Still occupied until the early twenty-first century, it is now derelict.

Both in Ayrshire and in Durham, several villages linked with coal mining have been abandoned. In Ayrshire most such villages comprised little more than a few rows of terraced houses. At the western end of the county, however, Glenbuck was a larger settlement, with a history going back to the seventeenth century. Coal mining thrived there in the nineteenth century and by 1900 the population had risen to about 1,750.

Glenbuck's biggest claim to fame was its production of football players, including seven Scottish international players. After the main coal pits were closed, people gradually moved away from Glenbuck. In the 1950s a new housing estate was developed in Muirkirk and some of the last residents of Glenbuck moved into two adjacent streets on the estate.

Did you know?

Bill Shankly, who enjoyed a highly celebrated career as manager of Liverpool Football Club, was born and grew up in Glenbuck.

In Durham, the County Development Plan of 1951 classified mining villages in four categories. For villages placed on the D list no future development would be permitted and

all properties in the settlements would be acquired and demolished. In the event, most Category D villages have survived, but several, including Bowden Close, Hedley Hall, and Marsden, were removed as a result of the policy.

Bothwellhaugh, about 10 miles south-east of Glasgow, was another coal mining village, close to the highly productive Hamilton Palace colliery. In 1910, 965 staff members and their families occupied a total of 458 houses. The colliery was closed by the National Coal Board in 1959. Some residents remained, but the opening of the M74 motorway and the development of Strathclyde Country Park caused the village to be entirely demolished. During the last two years after 1969 the last official resident was Janet Frew, wife of the former deputy pit manager. She was joined by a group of gypsies. She would supply water to the gypsies, and in return they would 'look out' for her.

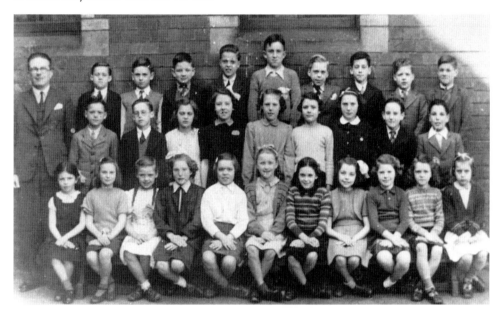

Above: A class from Bothwellhaugh School in 1946. The teacher at the back is Hamilton Liddell, and the two boys next to him are A. Neil and W. Whaley. There is no sign of a school uniform. (Matt Mitchell)
Right: George Murie, a dairy farmer who delivered milk to Bothwellhaugh from 1929 to 1939. (Matt Mitchell)

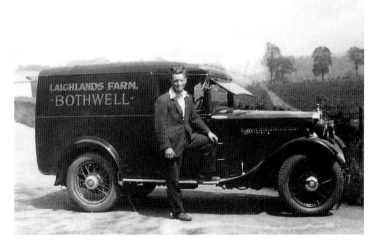

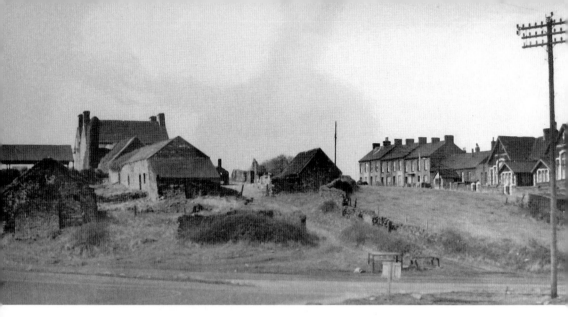

Machynys Farm on the left, Cliff Terrace and Machynys School on the right. (Nevil Williams)

A jumble sale in Machynys intended to raise money for starving people in Biafra during the attempt by the state of Biafra to secede from Nigeria in the late 1960s. This photograph was supplied by Sandra Jenkins and Mavis Smith; Mavis is second from the left in the picture.

Machynys is a peninsula close to Llanelli in Carmarthenshire. For most of the nineteenth century and the first half of the twentieth century, Machynys was a centre for industrial production, specialising in particular in the production of tinplate. Two small communities, Machynys and Bwlch-y-Gwynt, grew up among the factories. However, the last tinplate factory closed in 1961 and the residents of Machynys and Bwlch-y-Gwynt were compelled to move away when their homes were demolished around 1970. The peninsula lay derelict for about twenty years, but today it is occupied by a golf course and, on its western side, an upmarket housing estate. Sandra Jenkins and Mavis Smith, who grew up next door to each other in Sea View Terrace, still feel sad and angry about being made to leave Bwlch-y-Gwynt.

7
Military Training

At the beginning of the Second World War, land was required for military training. The need for practice in live firing entailed a search for large open areas with as few inhabitants as possible. In 1940 the Sennybridge Training Area (SENTA) was created on Mynydd Epynt in Powys, and two years later the Stanford Training Area (STANTA) was developed in Norfolk.

Both areas were sparsely populated, but on Epynt a farming community and the village of Cilieni had to be removed. A total of 219 people from fifty-four homes were evicted. Epynt was a Welsh-speaking community, with a small school and a chapel – the Babell Chapel – in Cilieni. Every Christmas morning, Annie Williams would get up at 5 a.m. to light the oil lamps and the stove in the chapel, ready for the service known as Plygain. Soon afterwards each family would arrive, carrying a stable lamp to help them see the way. Social events were also held in Babell Chapel, including a regular eisteddfod – a series of musical competitions with particular emphasis on choral singing.

After the evacuation, some of the residents attempted to maintain contact with Epynt, perhaps hoping that the war might end soon and it might be possible to return. Thomas Morgan from Glandwr used to slip back to his farm and light the fire to keep the house aired.

A farmhouse and a military tent on Mynydd Epynt. In all military training areas you will find a strange mixture of old and new.

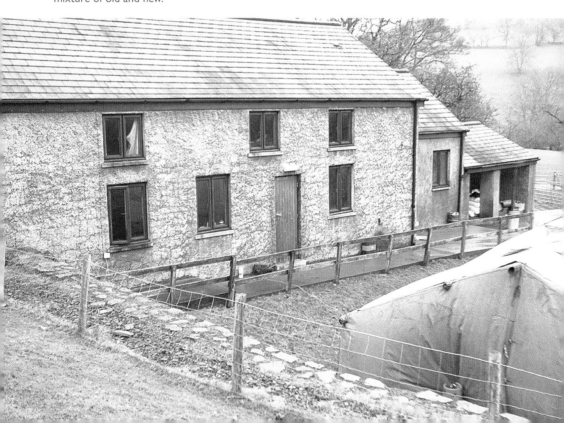

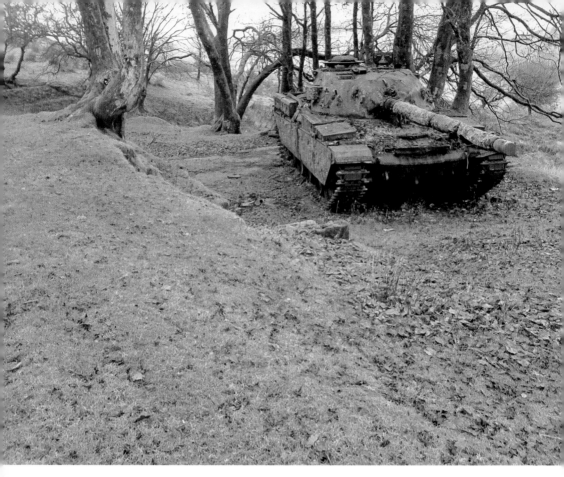

The site of Caerllwyn farmhouse on Mynydd Epynt. In 1940 Griffith and Megan Price lived there with their children. (Philip Evans)

One day he arrived to find his home in ruins. An army captain told him it had been blown up and he was not expected to come back again.

A few homes on Epynt have survived, but for training in urban warfare several mock buildings were built and then a mock village in the 1980s – an astonishing set of buildings intended to simulate a typical German village. It was expected that if the Cold War with the Soviet Union broke into open hostilities it would happen in East Germany.

In Norfolk four small villages and two hamlets were depopulated to create STANTA. As the local people had already heard explosions and seen tanks on their land well before they were evacuated, they were not entirely surprised when they were informed that their properties were to be taken over. Lucilla Reeve published her memories of the war years in *Farming on a Battle Ground*. She described two public meetings when people were told about the takeover, and the reactions of confusion, anxiety and anger. Reeve herself worked as a land agent, but also began farming in 1938 when she rented Bagmore Farm near Tottington. Before the day of departure in July 1942 she and other farmers had to dispose of their livestock and hay, and hope they would still be able to return to harvest their crops. On the day itself they had to decide what furniture and belongings to take with them and what would have to be left behind. Lucilla Reeve moved into three former poultry sheds and tried to make them a temporary home. In October that year she was able to resume a limited amount of farming at

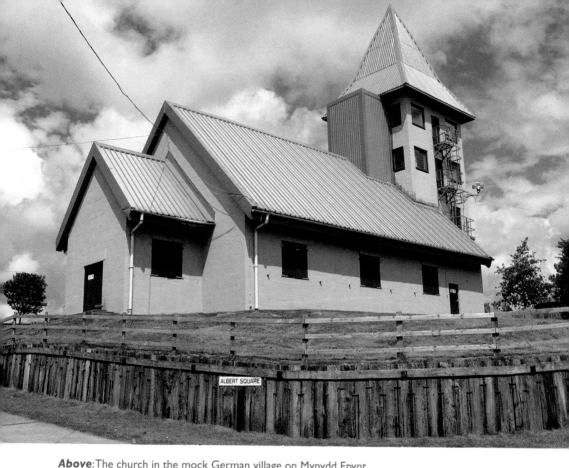

Above: The church in the mock German village on Mynydd Epynt.
Below: Tyneham village is open to the public nearly every weekend. The K1 telephone kiosk is a special attraction. The K1 was Britain's first standard kiosk. The original kiosk in Tyneham was damaged by a film company in 1985, but the replacement has been made as authentic as possible.

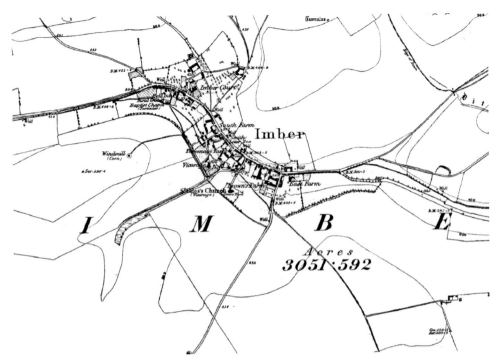

Above: Imber in 1889. Imber Court was the main house in the village. Services are still held occasionally in St Giles Church, and the BBC's *Songs of Praise* was filmed there in 2011.

a small farm in Great Ellingham. However, it seems she never fully recovered from the ordeal, and she committed suicide in 1950.

In southern England two villages were cleared in December 1943: Tyneham and Imber. Tyneham was enclosed by Lulworth Range and Imber was located on the part of Salisbury Plain already devoted to military training.

At Imber most of the men were engaged in agricultural work but often they pursued a variety of other jobs, professions or cultural activities as well. Harry Meaden, for example, was the village boot and shoe maker, but would also take a turn at sheep shearing. In addition he was a church elder, taking services accompanied by a small dog. Postmen would complete their rounds on foot or by bicycle and then perform odd jobs around the village until it was time to collect the outgoing mail at around 4.00 p.m.

For safety reasons and to provide opportunities for training in built up areas, it was decided in the Second World War that both villages should be closed. In both cases the people of the village were given notice just a few weeks before they were required to leave. At Imber, for example, they were informed about the evacuation on 1 November and told they had to depart by 17 December.

Did you know?

After everyone had left Tyneham a note was found left on the door of the church. It read: 'Thank you for treating the village kindly.'

At both Tyneham and Imber the people were confident that they had been given a pledge that they could return to their homes when the war came to an end. It appears that the authorities did indeed create the impression that this would be allowed, but as no such commitment was ever put in writing it was not possible for either village to be re-occupied. In regard to Imber, protests and demands to allow former residents to return occurred from time to time, especially after the Ministry of Defence took steps to restrict public access to the village. The Association for the Restoration of Imber was set up in 1961, but early in 1962 a final decision was taken that public rights of way through Imber would not be restored. By then it was clear that former residents would not be allowed to go back.

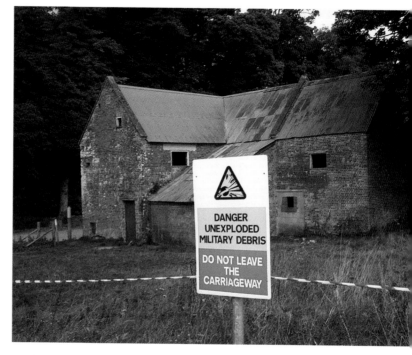

The Bell Inn in Imber. At least one of the landlords at the Bell Inn also controlled the Imber windmill before the windmill was demolished early in the twentieth century.

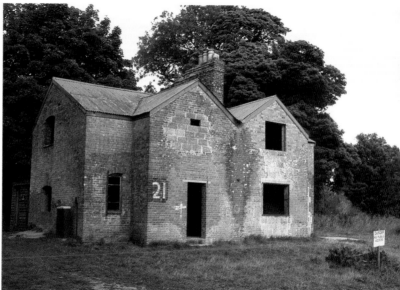

House 21 at Imber, left standing to allow training in methods of warfare in urban settings.

8
Cities

The villages we have visited so far have been located in the countryside or close to the sea. However, there are also many examples of districts within large towns or cities that have been abandoned. For the people who were forced to move out, the process of departing and starting a new life in another home would generally have been just as traumatic.

The demolition of urban districts has had various motivations. In this chapter we will consider areas in London, Glasgow and Cardiff that illustrate some of the causes.

Palmer's Village in London was demolished around 1850 to make space for the building of Victoria Street. In the seventeenth century, almshouses had been opened by James Palmer at the western end of Westminster. At the same time homes were built nearby to provide rent that would support the running of the almshouses. This small district was known as Palmer's Village. It was created in the north-west corner of Tothill Fields, a large area that continued to be used for the production of crops and vegetables, and for various less reputable purposes, until the early nineteenth century.

The memorial to James Palmer in St Margaret's Church. Part of the inscription reads: 'A most pious and charitable man exprest in severall places by many remarkeable actions & particularly to this parish in building fayer almes houses for 12 poor olde people with a free school and a comodious habitation for the scoolmaster.'

Did you know?

There is a large memorial to James Palmer on the north wall of St Margaret's Church, Westminster, close to the Houses of Parliament. It was damaged by an oil bomb on 25 September 1940.

Information about the people living in Palmer's Village during the decade before its removal comes from a number of sources. In 1846 Revd Alfred Jones compiled a statistical report intended to convey a picture of the social conditions prevalent in the local parishes. Looking at the figures for Palmer's Village we see that in Providence Row, for example, there were fifteen houses, twenty-nine families, and 130 individuals, with three out of forty-three children attending an infant school and six a day school. On some of the more morally loaded

Part of Horwood's map, published in 1813. Palmer's almshouses are those running north to south on the east side of a narrow street in the top right corner of this section of the map.

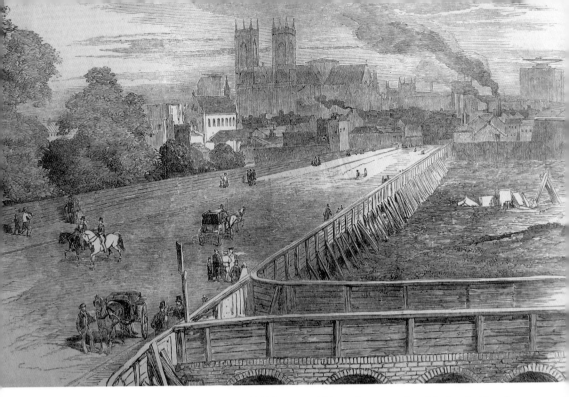

Victoria Street viewed from the west. Palmer's Village would have been on the right-hand side of Victoria Street. From the *Illustrated London News*, 6 September 1851.

statistics the village came out very well compared with the part of St Margaret's parish to the east, closer to the Houses of Parliament. In particular, Jones found only two brothels and six prostitutes in Palmer's Village.

In 1853, two years after the opening of Victoria Street, Charles Manby Smith recorded his memories of Palmer's Village as it had been around 1830. He recalled the village barber, who plied his trade mainly on Saturdays. He spent the rest of his time in strop-making, travelling around London every Monday to sell his wares. The blacksmith combined his trade with being a capable musician. On a Sunday afternoon you could hear him hammering out on a set of hanging bells the psalm tunes he had heard at Westminster Abbey that morning.

Orchard Place was a community on the north bank of the River Thames, where the River Lea enters the Thames. It developed after the East India Docks opened in 1803. The docks stimulated the growth of a wide range of industries, and small pockets of housing were created among the factories and warehouses. Opening off the west side of Orchard Place, for example, a cul-de-sac of nineteen brick cottages was erected in the late 1820s. A larger development of houses, shops and the Crown public house came into being after 1839.

Several cities in Britain engaged in extensive slum clearance during the 1930s. The London County Council identified Orchard Place as one of the worst slum areas in London. Within a few years nearly all of its housing had been removed.

Further east along the Thames, Silvertown is a district close to what used to be the three Royal Docks. All of Silvertown was severely damaged by bombing during the Second World War, but the central part of it suffered the worst damage. When the painter Graham Sutherland visited Silvertown in 1941, he saw 'the shells of long terraces of houses, surprisingly wide perspectives of destruction seeming to recede into infinity. The windowless blocks were like sightless eyes'. Most of the women and children had been evacuated early in the war, but

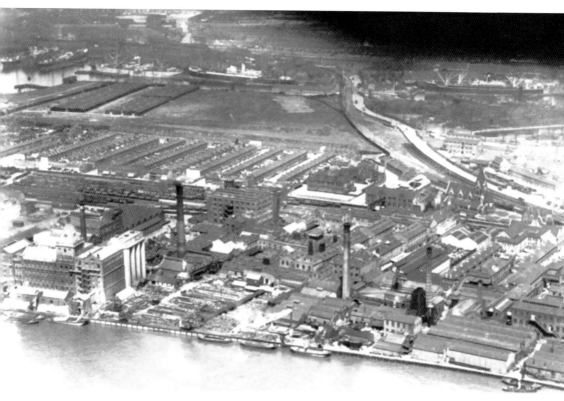

Central Silvertown in 1921. The terraces where most of the people of Central Silvertown lived were along the parallel streets on the far side of the railway sidings. Oriental Road ran along the northern edge of the district. (Stan Dyson)

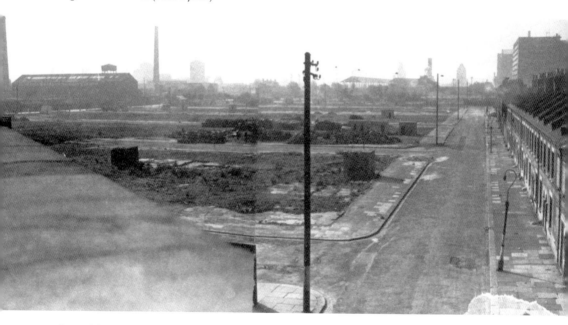

Central Silvertown soon after the end of the Second World War. The northern side of Oriental Road is the only part left standing. (Stan Dyson)

Grahamston around 1860. The gas holder, several warehouses and industrial buildings and St Columba's Gaelic church are marked. Many of the other buildings were tenement blocks housing the people of Grahamston.

men who worked locally often remained. The house of Arthur Davies at 13 Arthur Street took a direct hit and was completely destroyed, but fortunately Arthur himself was visiting his parents further down the road when the bomb struck.

From the electoral registers for 1939 and 1945 we know that the number of voters in Central Silvertown fell from 1,155 to sixty-four. The few houses still standing were demolished soon after the war, and the area was turned into an industrial estate.

In the eighteenth century Grahamston was a village just outside the western boundary of Glasgow. It was incorporated into Glasgow in 1830. By that date it contained a mixture of houses, shops and industrial enterprises. However, while the shops and businesses continued to expand there was a gradual decline in the number of residents. In the census of 1841 the population of Grahamston was 1,924 but it had fallen to 575 in 1871. Around 1870, the Caledonian Railway Company decided that Grahamston would form a suitable location for its main terminus in Glasgow. Nearly all of Grahamston was demolished and the station, now known as Glasgow Central, opened in 1879.

Only two buildings still remain from Grahamston, Nos 186–190 Argyle Street and a hotel now called the Rennie Mackintosh on Union Street. If you come into Glasgow Central by train from the south you may get out at Platform 3. If so, you will be directly above the line of the former Alston Street.

Cardiff expanded rapidly throughout the nineteenth century. Most of the residential developments of that time have survived, but two districts, Temperance Town and Newtown, have disappeared. More than a thousand people lived in each of those districts, but they had to move out in 1937 and 1966 respectively, and their homes were demolished.

Nos 186, 188 and 190 Argyle Street, one of just two buildings surviving from Grahamston. Most of the ground floor is now the Grant Arms. In the eighteenth century a brewery stood on this site.

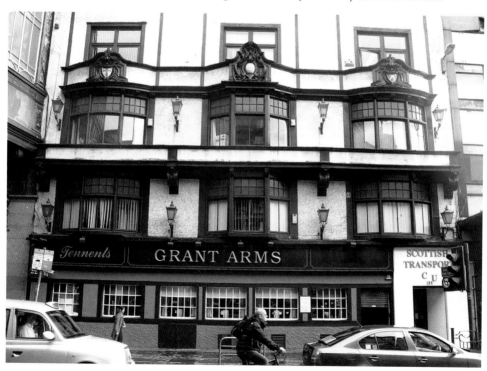

Glasgow Central Station. The main street through the centre of Grahamston, Alston Street, lay underneath Platform 3.

Newtown, south of the city centre, came into being in 1846 to provide housing for Irish migrants employed in building Cardiff Docks. It was known for its strong community spirit. Several pubs and beer parlours were opened, and in the 1870s St Paul's Roman Catholic church was built, with a school attached to it. Temperance Town was created in the early 1860s in front of Cardiff Central railway station. It gained its name because Colonel Edward Wood, the owner of the land on which it was built, tried to prevent the development of any alcohol related trades within it.

In both communities parades and processions were popular. Processions proclaiming the virtues of abstinence were often seen making their way through Temperance Town. People from Newtown would turn out every St Patrick's Day to join the parade from St Paul's Church through the city centre. A celebrated resident of Newtown was the boxer Jim Driscoll. When he died in 1925 huge crowds lined the roads as his coffin was carried from St Paul's Church to a cemetery in north Cardiff.

By the 1930s both Temperance Town and Newtown were condemned as slum areas. In addition Cardiff Corporation had its eye on Temperance Town as they wanted to improve the approach to the railway station and build a bus station. The shops, businesses and houses in Temperance Town were demolished in 1937. Newtown survived for longer, but in 1966 its buildings were taken down and it was replaced by a trading estate.

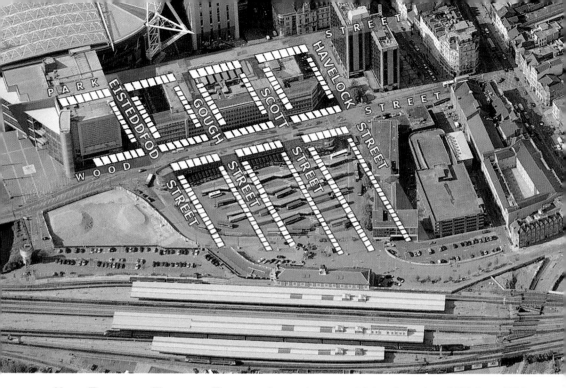

Above: The streets of Temperance Town superimposed on an aerial view from about 2008. Since 2008, the area has been re-developed again. (Matthew Witty)

Below: Gough Street, Temperance Town, looking south towards Cardiff Central railway station. The shop of T. H. Binstead, leather merchant, can be seen on the left. (Glamorgan Archives)

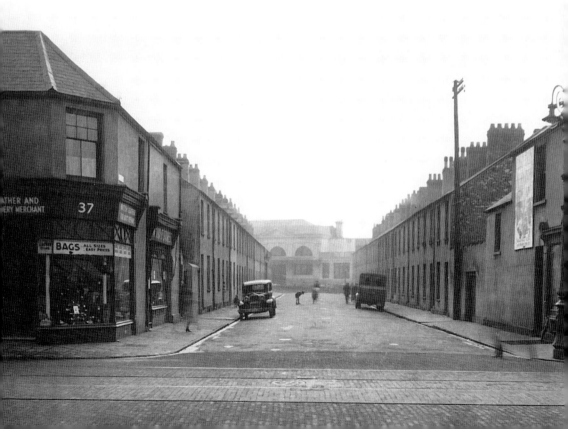

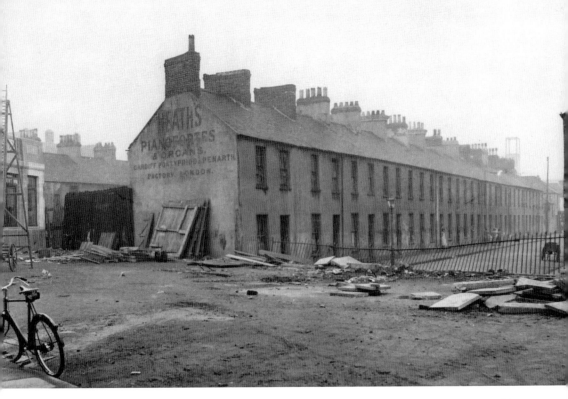

Above: Gough Street, Temperance Town, looking north, just before demolition in 1937. (Glamorgan Archives)

Below: The memorial garden in memory of the people of Newtown. It is located on Tyndall Street, Cardiff, over the road from where Newtown used to be. Over 200 surnames have been inscribed in

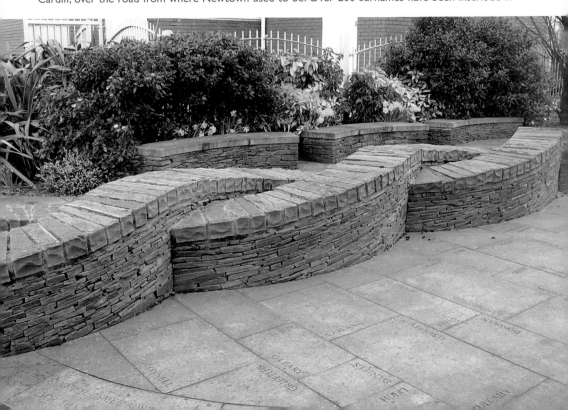

9
What Next?

Nearly all abandoned villages are worth visiting. There may be nothing left to see of the former village, but you will still get a good idea of the context in which it was set. You are likely to find yourself imagining the kind of life that the village inhabitants would have led, whether it was seven centuries ago or just fifty years, and the ordeal they endured when they were compelled to leave.

The sites of deserted medieval villages will often be marked by an isolated church and features in the surface of the ground that indicate the foundations of houses, boundaries or fields. At villages abandoned more recently the ruins of houses and other buildings may still be visible. Occasionally, as at Porth y Nant in Gwynedd, the village has been restored and converted into a new type of community.

Some villages have a series of information boards that will help you interpret what you see. Good examples are Wharram Percy in Yorkshire; Godwick deserted medieval village

the stone paving to record Newtown family names from four generations.
The site of the village of Rosal in Strathnaver. Splendid information boards at several places around the

Cosmeston, the only deserted medieval village that has been reconstructed. This photograph shows site will give you a good impression of life there in the early eighteenth century.

in Norfolk; Haslingden Grane in Lancashire; Forvie, not far from Aberdeen; Rattray, near Peterhead; and Rosal in Strathnaver.

The only deserted medieval village that has been restored to its original state is Cosmeston, which is not far from Cardiff. You can explore the houses and farm buildings, and learn much about the way of life of its fourteenth-century inhabitants from the furniture, tools and other possessions on display.

Any visit to the site of an abandoned village will be enhanced by knowledge of its history and the reasons for its abandonment. There are plenty of relevant books and online resources.

The classic book on deserted medieval villages is *The Lost Villages of Britain* by Maurice Beresford (originally published in 1954, but a revised edition was published by Sutton Publishing in 1998). Other general books on abandoned villages are:

Buckton, Henry, *The Lost Villages: In Search of Britain's Vanished Communities* (I. B. Tauris, 2008).
Driver, Leigh, *The Lost Villages of England* (New Holland, 2006).
Muir, Richard, *The Lost Villages of Britain*, originally published in 1982 but reprinted several times.

Some books describe villages in a particular county:

Davison, Alan, *Deserted Villages in Norfolk* (Poppyland Publishing, 1996).
Dawson, Dick, *Lost Villages of Bedfordshire* (Streets Publishers, 2007).
Love, Dane, *Ayrshire's Lost Villages* (Carn Publishing, 2016).
Vigar, John, *The Lost Villages of Sussex* (Dovecote Press, 1994).

There are many books about individual villages. Here I will recommend:

Beresford, Maurice and Hurst, John, *Wharram Percy Deserted Medieval Village* (B. T. Batsford and English Heritage, 1990).
Gilliland, Norrie, *Glasgow's Forgotten Village: The Grahamston Story* (Grahamston Publications, 2002).
Francis, Peter and Wall, Tom (ed.), *Once Upon A Hill: The Lost Communities of the Stiperstones* (Scenesetters, 2011).
Holt, Allen, *Watergrove: A History of the Valley and its Drowned Community* (George Kelsall, 2002).
Melia, Steve, *Hallsands: A Village Betrayed* (Forest Publishing, 2002).
Parker, Rowland, *Men of Dunwich* (Holt, Rinehart & Winston, 1978).
Prebble, John, *The Highland Clearances,* originally published in 1963, but published again in several later editions.
Sawyer, Rex, *Little Imber on the Down* (Hobnob Press, 2001).
Steel, Tom, *The Life and Death of St Kilda* (Fontana, 1975).
Thomas, Einion, *Capel Celyn,* Cyhoeddiadau Barddas a Chyngor Gwynedd, bilingual edition published in 2007.

I also have to mention a delightful book by Eileen Thomas who lived as a child in Porth y Nant, *This Valley Was Ours*, which was first published in 1983, but published again in 1997 and 2007 by Gwasg Carreg Gwalch.

When it comes to online resources, Google and Wikipedia will help you a lot more than I can, but here are a few suggestions. As far as I know there is only one website that covers abandoned villages throughout Britain, my own website at www.abandonedcommunities. co.uk. Deserted medieval villages in England are catalogued in the Beresford's Lost Villages website at www.dmv.hull.ac.uk/index.cfm, which provides links to detailed Google aerial views. Websites that cover a county or region include:

Lonely Isles: paulmclem.weebly.com/abandoned-isles.html. Islands off the coast of Scotland.
Literary Norfolk: www.literarynorfolk.co.uk/deserted_villages.htm. Deserted villages in Norfolk.
Wilgisland: www.wilgilsland.co.uk/page2.html. Villages along the coast of Holderness in East Yorkshire destroyed by coastal erosion.

Among websites devoted to a single village my favourites are:

Legendary Dartmoor: www.legendarydartmoor.co.uk/hound_sett.htm. A superb account of the village at Hound Tor.

Tyneham OPC: at www.tynehamopc.org.uk. Information and photos of Tyneham in Dorset.
Disused Stations: www.disused-stations.org.uk/r/riccarton_junction/index.shtml. All about Riccarton Junction, a railway station and small community in Scotland, close to the border with England.

Several abandoned villages have a museum or heritage centre within a few miles that may have information about the village, helpful illustrations and maps, old photographs and the recorded reminiscences of people who lived there. I can especially recommend the following:

Dunwich Museum; among the many items on display, make sure you stop to have a good look at the three-dimensional model of Dunwich as it may have appeared in 1200.
Burntisland Heritage Centre, close to Binnend in Fife.
Strathnaver Museum in Bettyhill, including its splendid simulation of the interior of a typical Highland home.
Seaford Museum in East Sussex, close to Tide Mills, especially recommended for its collection of the memoirs of Tide Mills inhabitants.
Cookworthy Museum in Kingsbridge, Devon, a couple of miles from Hallsands.

If you are still inclined to dig deeper into the history of an abandoned village then look for the local history section of the nearest public library or visit the county archives. Search for contemporary documents, maps, old photographs or newspaper articles that will tell you about major events in the village while it still existed or describe the process of evacuation. From my own experience I can tell you that staff are nearly always very happy to assist your search, possibly to the extent of interpreting documents that are several centuries old.